# CARLISLE

## HISTORY TOUR

*In memory of my Nan, Marian Howorth (1925–95)*

*With thanks to Charlie Emett and James P. Templeton, authors of
'Carlisle Through Time'*

First published 2018

Amberley Publishing
The Hill, Stroud,
Gloucestershire, GL5 4EP
www.amberley-books.com

Copyright © Billy F. K. Howorth, 2018
Map contains Ordnance Survey data
© Crown copyright and database
right [2018]

The right of Billy F. K. Howorth to be
identified as the Author of this work
has been asserted in accordance with
the Copyrights, Designs and Patents
Act 1988.

ISBN  978 1 4456 8241 9 (print)
ISBN  978 1 4456 8242 6 (ebook)

British Library Cataloguing in
Publication Data.
A catalogue record for this book is
available from the British Library.

Origination by Amberley Publishing.
Printed in Great Britain.

# INTRODUCTION

The city of Carlisle, often referred to as the Great Border City, has a long and unique history that is heavily connected to the nations of both England and Scotland. It has been an important strategic stronghold for millennia due to its location around 10 miles south of the border with Scotland. Carlisle is located at the meeting point of the three rivers – the Eden, Caldew and Petteril – and was historically located in the county of Cumberland until 1974, when the county was combined with Westmorland, part of Lancashire and part of the West Riding of Yorkshire.

The history of people living in the city can be traced back to the time of the Roman Empire, when the first Romans settled in the area during the first century AD. They constructed a fort known as Luguvalium, which was located where Carlisle Castle now stands. The roman town was built to serve the roman forts located along the length of Hadrian's Wall. By the second century Carlisle was a vital stronghold on the Stanegate frontier, which comprised of the fort of Luguvalium and several others stretching eastwards to Corbridge and provided an additional line of defence.

The occupation of the town after the fall of the Western Roman Empire during the fifth century seems to have continued. Through local excavations, the remains of buildings dating to this period have been discovered with the area coming under the control of the kingdom of Rheged led by King Urien.

With the arrival of the Normans, the city began to expand once again with a new castle and cathedral constructed during the twelfth century. The town continued to flourish through the Middle Ages, becoming an important

market town, and during the nineteenth century underwent huge industrial changes due to advancements during the Industrial Revolution.

A major problem for early travellers to the area was the lack of suitable tracks, with Cumbria known for its steep hills and mountains and long winding valleys. It was with the introduction of turnpike roads during the eighteenth century that the area became more easily accessible.

In 1823 a canal was built to connect the town to Port Carlisle close to Bowness-on-Solway, located on the Solway Firth. The advent of rail transportation during the nineteenth century opened up the area further with reliable connections to Glasgow and Edinburgh in the north and the major English cities to the south via the West Coast Mainline. With the construction of the M6 motorway in the 1960s the north of England became easily reachable by car. The most northerly section of the motorway was opened in 1970, with the new road terminating just north of the city.

In the modern day, Carlisle is a well-known tourist city, owing much of its popularity to its location close to the Anglo-Scottish border and the Scottish village of Gretna Green, famous as a wedding location for eloping couples since the eighteenth century. The town is also famous for Carr's biscuits and is the birthplace of many famous people including the novelists George MacDonald Fraser and Margaret Forster, Melvyn Bragg and Janet Woodrow, who was the mother of President Woodrow Wilson.

This book would not have been possible without the work of the many writers who over the centuries have written about the history of this significant city, and also the work of artists and photographers who over the past hundred years or so have recorded the streets, buildings and surrounding area through their work.

# KEY

1. Fusehill Workhouse
2. Botchergate
3. Carlisle Train Station
4. The Citadel
5. The Botchard and English Gate
6. Victoria Viaduct
7. Warwick Road
8. Lowther Street
9. Lowther Street Congregational Church
10. The Gretna Tavern
11. Her Majesty's Theatre
12. Carlisle Grammar School
13. War Memorial Bridge
14. The Cenotaph
15. Rickerby Park
16. Eden Bridge Gardens
17. Eden Bridge
18. The Creighton Memorial, Hardwicke Circus
19. The Queen Victoria Monument
20. Bitts Park
21. Scotch Street
22. The Scotch Gate and Prison
23. The Covered Market
24. The Chapel of St Alban's
25. The Marketplace
26. The Market Cross
27. The Old Town Hall
28. Glover's Row
29. The Crown and Mitre Hotel
30. The Guildhall
31. English Street
32. Highmore House
33. The Steel Monument
34. St Cuthbert's Church
35. Carlisle Cathedral
36. The East Window, Carlisle Cathedral
37. St Mary's Church
38. The Archway
39. Abbey Street
40. Tullie House
41. Carlisle Castle
42. The Irish Gate
43. The West Walls
44. Dixon's Chimney and Shaddon Mill
45. Carr's Biscuit Factory
46. Caldewgate
47. Holy Trinity Church
48. The Old Cumberland Infirmary
49. Port Carlisle

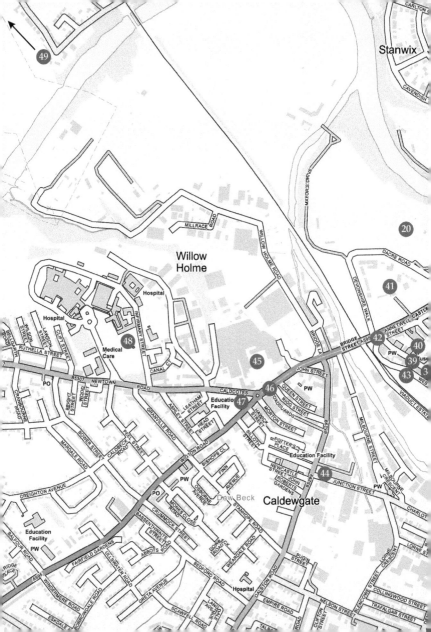

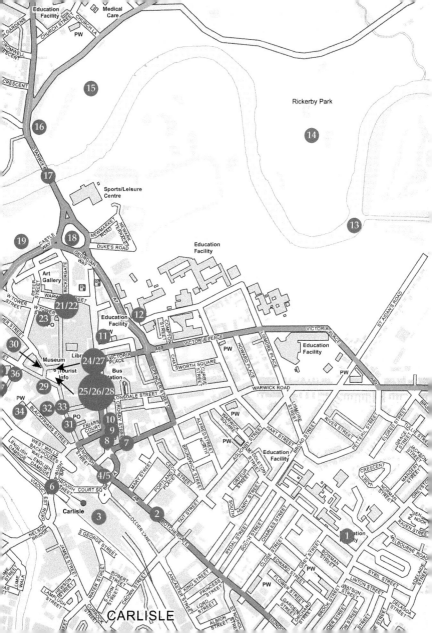

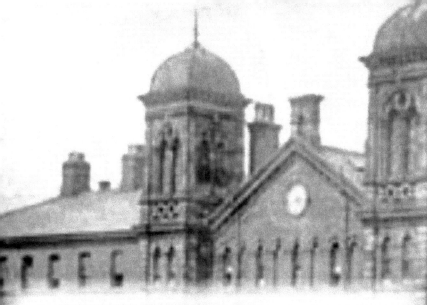

# 1. FUSEHILL WORKHOUSE

The former Fusehill Workhouse was constructed in 1863 as there was an urgent need for a new purpose-built facility in the town. The new workhouse design was decided by a competition commissioned by the Carlisle Poor Law Union. The winners were Henry Lockwood and William Mawson, who had previously drawn up plans for of other workhouses including Bradford, Haslingden and North Bierley. Their new workhouse in Carlisle was able to accommodate 478 inmates. As well as the site housing the main workhouse, a smaller building was also constructed which was used as an infirmary. It was decided that Fusehill should be converted for this purpose during the First World War. The hospital continued to treat wounded soldiers until its closure in 1919. After this period, it once again became a workhouse and in 1938 was converted into a hospital, later used to treat soldiers during the Second World War. The hospital closed at the site in 1999, when the building became part of the University of Cumbria campus.

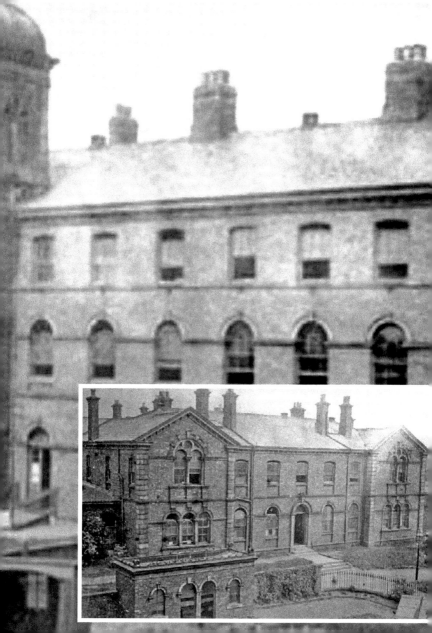

# 2. BOTCHERGATE

Originally the area around Botchergate was located outside of the city perimeter and marked the route into the city from the south. The area was originally known as Botchardgate and was owned by the Botchard family from Flanders around the time of Henry I. During the Middle Ages it had a somewhat unique and uncivilised character, being home to many hostelries and inns; it was also home to St Nicholas' leper hospital. The reason for this was that during the reign of Elizabeth I, an ordinance was set out that forced the gates of the city to be closed after dark. This meant that travellers or locals who were outside of the city at this time needed somewhere they could stay until morning. During the eighteenth and nineteenth centuries the area became part of the newly expanded city. New houses for the working class were constructed in addition to new industrial buildings, alongside public houses, shops and new hotels, which can be found towards the north of Botchergate, close to the train station.

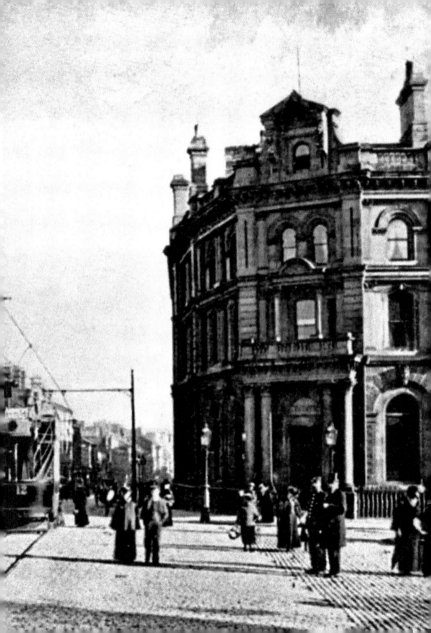

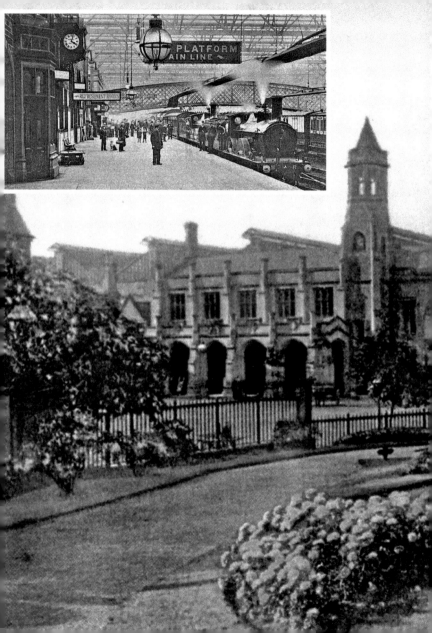

# 3. CARLISLE TRAIN STATION

Carlisle Railway Station, sometimes referred to as Carlisle Citadel Station due to its proximity to the Citadel Buildings, is now the main railway hub for the city. The station building was built in 1847 and was designed by William Tite in the neo-Tudor style. When it opened it was one of several stations in Carlisle, with the Maryport & Carlisle Railway Station located in Crown Street and the Newcastle & Carlisle Railway Station to be found on London Road. By 1851, the Citadel Station had become the main station in the town. Between 1875 and 1876, the station was expanded and extended to accommodate the new Midland Railway. It also became the northern terminus of the Settle & Carlisle Railway. Later in the 1960s, the railways were undergoing significant changes and the Beeching Axe meant that many railway lines were closed. These included the line that connected the town to Silloth and the Waverley Route, which connected Edinburgh via Galashiels to Carlisle.

NO DO
ALLO

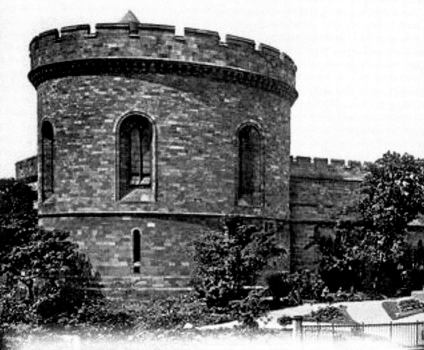

# 4. THE CITADEL

The original citadel building was constructed in 1541 under the order of Henry VIII. He requested that two imposing fortified towers be constructed to act as a second defence for the town, sitting at its southern edge. Over the subsequent centuries the towers fell into a poor state and in 1807 it was decided to demolish the towers. They were replaced with two new towers that were a similar design to the original medieval ones and housed the assize courts and a prison.

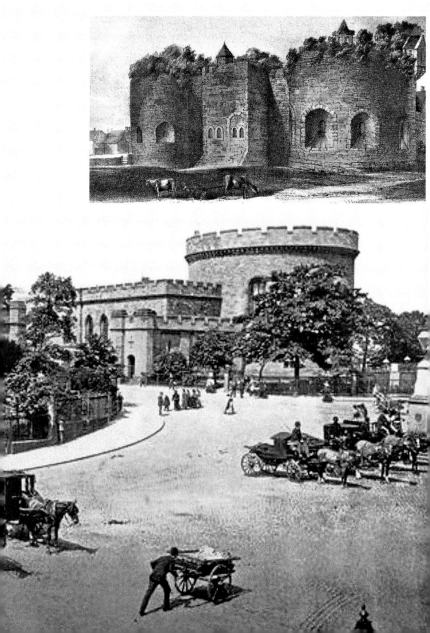

# 5. THE BOTCHARD AND ENGLISH GATE

Since the Middle Ages the main route into the city from the south was via Botchergate. Standing at the head of the road next to the Citadel Buildings was the city's southern defensive gateway. Interestingly, it appears that there were two gateways located in close proximity. The space between the two citadel towers was originally the location of the Botchard Gate and acted as the main southern entrance, with records dating from 1210 mentioning the gateway. By the beginning of the nineteenth century the gate has almost disappeared, with all remaining traces removed during the construction of the new courthouse. The other gate that stood close by was the English Gate; however its name is not entirely accurate as it has been suggested the structure was more like a sally port than a full-sized gateway. The English Gate was demolished in 1811 and its foundations completely removed in 1817.

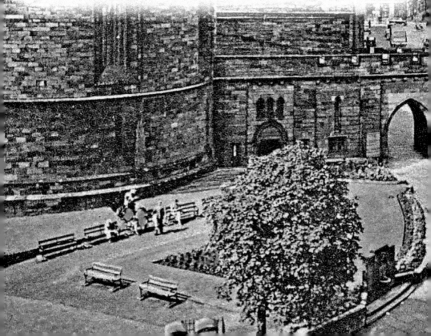

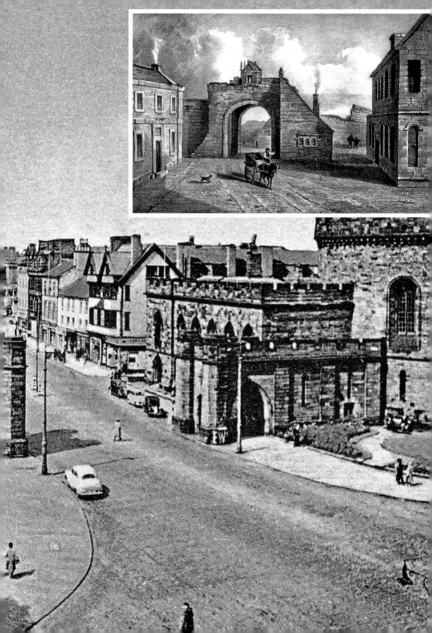

# 6. VICTORIA VIADUCT

One of the lesser-known sites in the city is the Victoria Viaduct, close to the train station. Work on the bridge began in 1876 and it was constructed by the Carlisle Corporation with some funding being provided by the railways companies. It allowed pedestrians and vehicles to pass over the main train lines, including the West Coast Mainline, which ran underneath the viaduct. It was officially opened on the 20 September 1877 by HRH the Princess Louise. A commemorative plaque of the event can be found just before the ornate iron railings when walking up the ramp towards English Street.

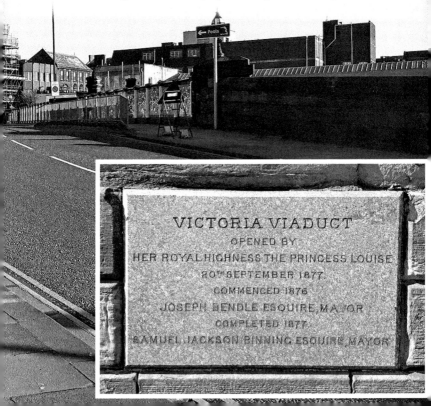

# 7. WARWICK ROAD

One of the main roads leading from the centre of the city is Warwick Road. It was originally constructed between 1829 and 1830 as a turnpike road connecting the city to the town of Brampton, around 9 miles east of Carlisle. Over the centuries the street has been home to many notable buildings including the new Carlisle Post Office, which opened in 1916, and Cavendish House, which was built in 1832 for Revd Thomas Woodrow, the grandfather of American President Woodrow Wilson.

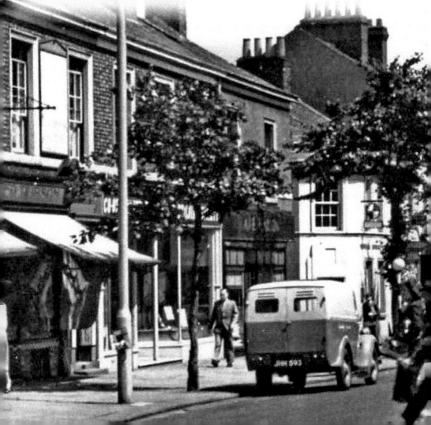

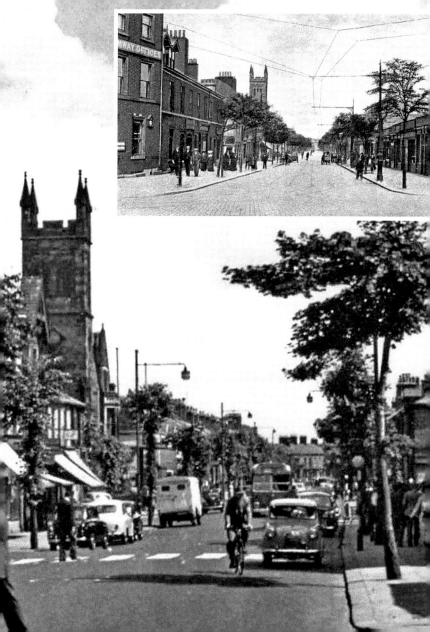

## 8. LOWTHER STREET

Another of Carlisle's main streets is Lowther Street, which begins close to the Citadel Buildings and travels northwards behind The Lanes shopping centre and almost parallel to English Street. It is notable as it has been the home of some of the most interesting buildings in Carlisle including the Lowther Street Congregational Church and old Gretna Tavern, as well as Her Majesty's Theatre. For centuries it was also home to Carlisle's Cockpit, the main fighting venue for the traditional blood sport. The venue was demolished 1876.

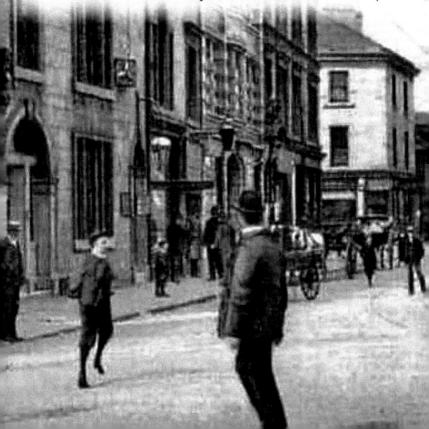

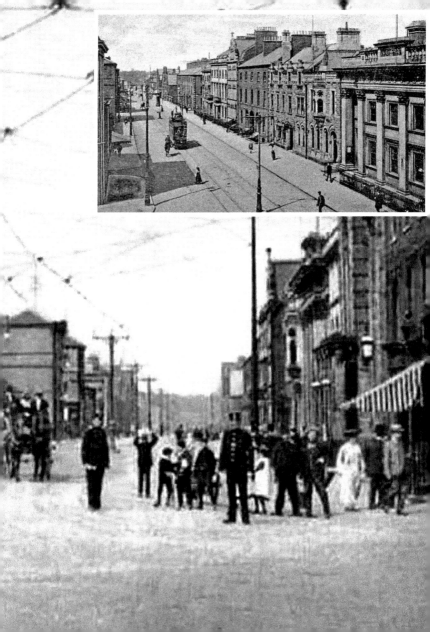

# 9. LOWTHER STREET CONGREGATIONAL CHURCH

Lowther Street is home to one of the town's least-known but most notable churches. It was designed by the architect John Nicol and officially opened on 19 March 1843 at a cost £3,000. It was built to house the Congregational Church, which had originally been located on Annetwell Street where Revd Thomas Woodrow was a preacher during the 1820s. Interestingly, he was the grandfather of President Woodrow Wilson, who visited Carlisle and the church during his 1918 visit. Over the decades the church has undergone very few alterations, the last being undertaken in 1936 when the building was repaired at a cost of £2,000.

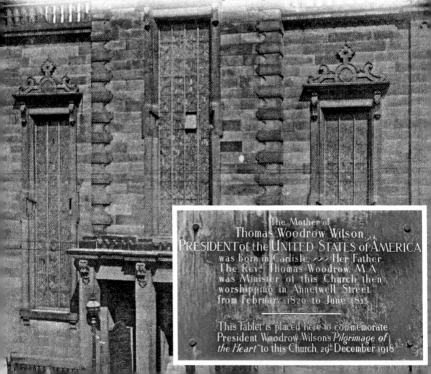

The Mother of
Thomas Woodrow Wilson
PRESIDENT of the UNITED STATES of AMERICA
was born in Carlisle. ~~ Her Father.
The Revd Thomas Woodrow, M.A.
was Minister of this Church then
worshipping in Annetwell Street
from February 1820 to June 1835

This Tablet is placed here to commemorate
President Woodrow Wilsons *Pilgrimage of the Heart* to this Church, 29th December 1918

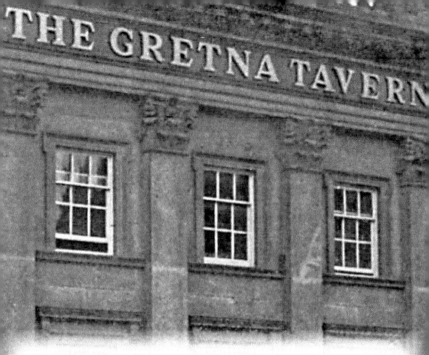

## 10. THE GRETNA TAVERN

The building was constructed in 1863 by J. Williams of London for Her Majesty's Office of Work to act as a new post office for the city. It underwent alterations in 1899 when a new storey was added to the building, making it the same height as the adjoining buildings. When the post office began to operate a telephone service in 1912 it needed a large building and moved to its new purpose-built building on Warwick Road in 1916. Once the post office had moved, it was converted into a pub and unusually it became the first pub in Carlisle to be state managed. Due to the closeness of the town to the armament factories in Gretna, it was decided nationalise the brewing, distribution and sale of alcohol in the city to prevent any issues related to the misuse of alcohol, with this unusual scheme in force from 1916–73.

# 11. HER MAJESTY'S THEATRE

The theatre was originally constructed in 1874 and known as the Victoria Hall. In 1897 it started to be used to show films for the first time and in 1904 was devasted by a fire. The interior was gutted and the same year it was decided to refit the theatre using plans drawn up by the architects Beadle and Hope. A year later the theatre was reopened under the new name of Her Majesty's Theatre, leased by Sydney Bacon. In 1919 it was decided that films should no longer be shown, and the theatre should instead be used for live performances. By the beginning of the 1960s the theatre was beginning to struggle and was renamed The Municipal Theatre, closing in 1963. The building later served as a bingo hall until its closure during the 1970s. It was demolished in 1979.

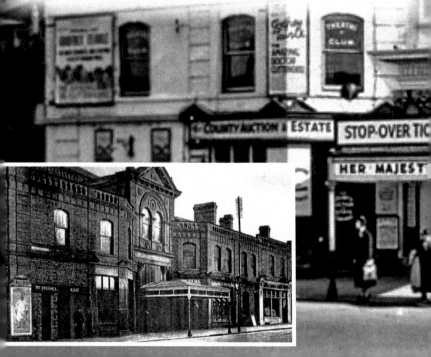

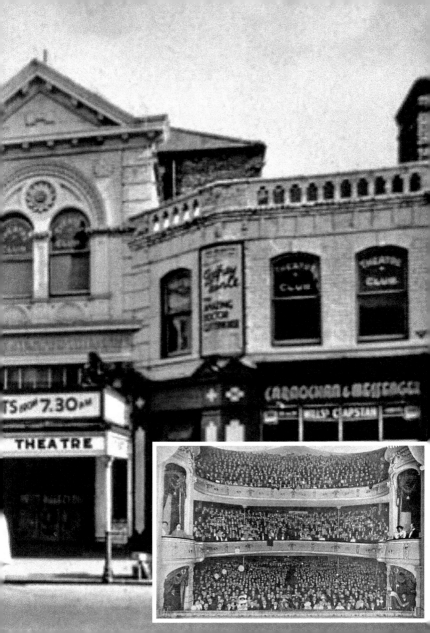

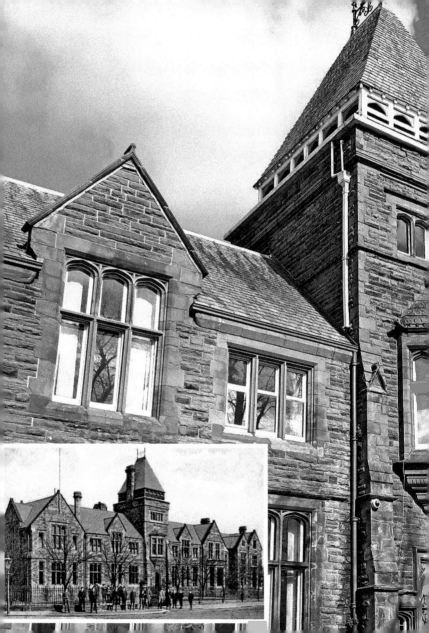

# 12. CARLISLE GRAMMAR SCHOOL

The history of education in Carlisle dates back many centuries to AD 685, when St Cuthbert, the Bishop of Lindisfarne, visited the city. During his visit he founded a church and school, close to the present-day Carlisle Cathedral. Later in 1545, the dean of Carlisle Cathedral took charge of the school, which occupied buildings along West Walls. At the same time the cathedral was rededicated to the Holy and Undivided Trinity. In 1883 the school became Carlisle Grammar School and it moved to a new purpose-built home on Strand Road, where it remained until 1968. During the 1960s the grammar school joined with two other local schools: the Creighton School for boys and the Margaret Sewell School for girls. The new school was called Trinity School.

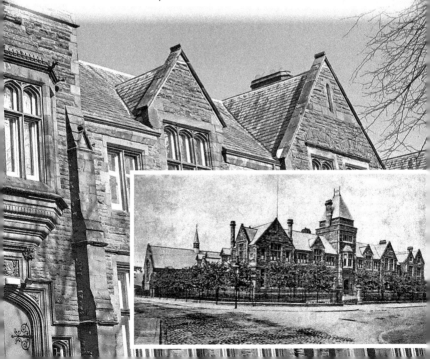

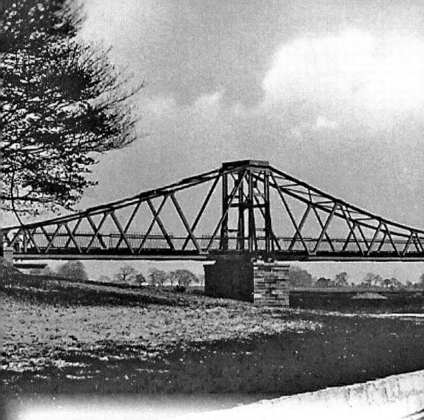

# 13. WAR MEMORIAL BRIDGE

The memorial suspension bridge was constructed by Redpath Brown & Co. to commemorate the lives of the soldiers who died fighting during the First World War. It spans the River Eden and the River Petteril meets the Eden close to the bridge. It also marks the starting point of the route that leads to the Cenotaph. The bridge was officially opened by 25 May 1922 and a cast plaque in the centre of the bridge marks the event and dedication. Nowadays the bridge forms part of the National Cycle Network and Hadrian's Path Cycleway.

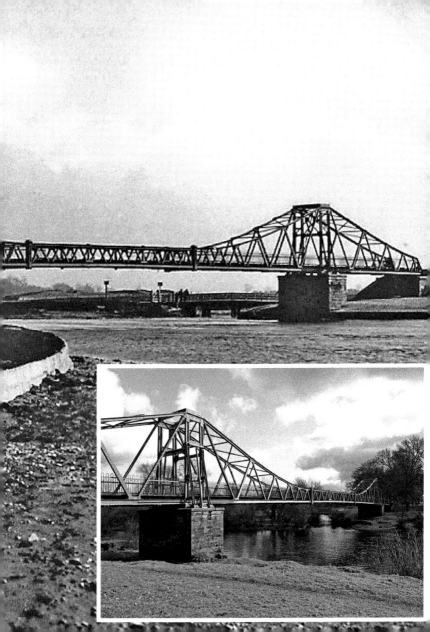

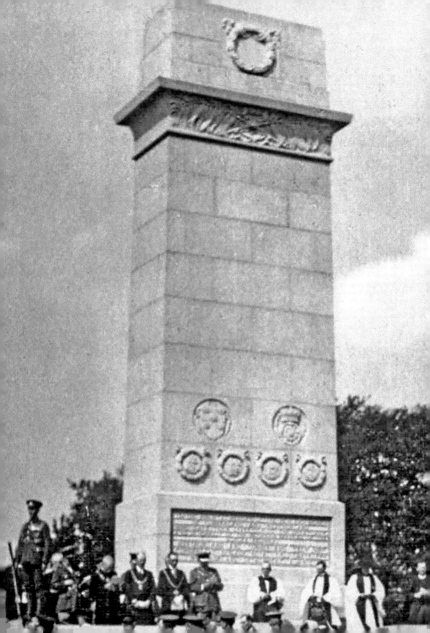

# 14. THE CENOTAPH

At the centre of Rickerby Park, close to the War Memorial Bridge, is the Cenotaph. Interestingly the memorial represents soldiers from two original counties: Cumberland and Westmorland. Designed by Sir Robert Lorimer and carved from local Shap pink granite, it stands around 40 feet high and cost £5,000 to erect. The design displays the insignia of the armed forces including the Army, Royal Navy, Royal Air Force and the Royal Army Medical Corps, as well as local branches including the Westmorland & Cumberland Yeomanry and Border Regiment. It was unveiled on 25 May 1922 by the Earl of Lonsdale and was such an important occasion that workers and schoolchildren were allowed to leave early – it is believed that around 25,000 people attended the event. After the Second World War a bronze plaque was added to commemorate the sacrifice of those who lost their lives fighting.

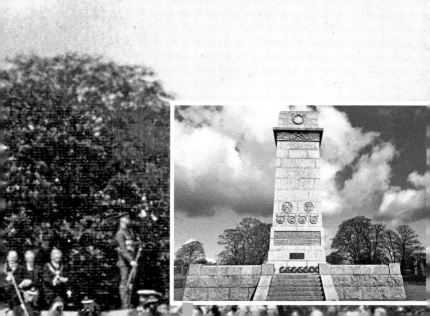

# 15. RICKERBY PARK

Rickerby Park is a large open area located on the northern banks of the River Eden. The history of the park dates back centuries to when the area was part of the manor of Rickerby. Over the decades the estate was owned by several wealthy families including the Pickerings, Gilpins, Richardsons and Rickerbys. The area was first landscaped around 1835. In 1914 the estate was broken up and sold off by the trustees of the MacInnes estate, who owned the land. Later in 1920, the Citizens League purchased the land for £11,500 to open it up as a public space and later to accommodate the war memorial. The park is most notable as the home of the Cenotaph, War Memorial Bridge and Eden Bridge Gardens.

# 16. EDEN BRIDGE GARDENS

Located close to the River Eden, Rickerby Park and Eden Bridge is the attractive Eden Bridge Gardens. The gardens were designed by notable architects Thomas Mawson & Sons and incorporated shrubs, borders and ornamental ponds, as well as places to sit to view the surrounding landscape. The project was overseen by Percy Dalton, who worked as a city engineer. He utilised the labour of unemployed workers who had lost their jobs during the Depression of the 1930s. To keep costs down the garden used reclaimed materials where possible, including stone from the old Eden Bridge, which was widened in the 1930s, and sandstone from the old gaol, which was located in English Street. Even with all the recycled materials the final cost was just over £3,000. The new gardens were officially opened in 1933.

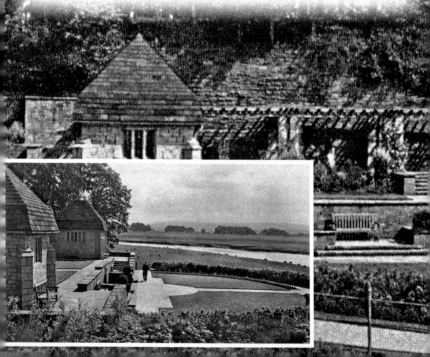

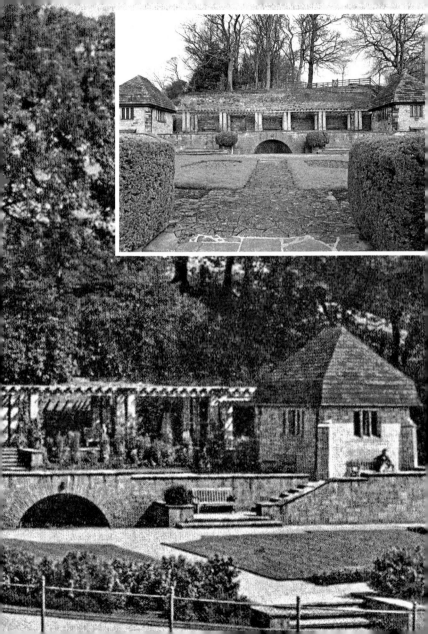

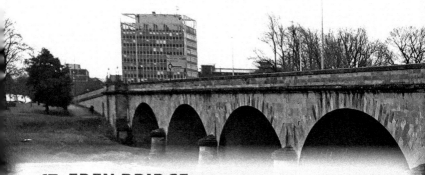

# 17. EDEN BRIDGE

The current incarnation of Eden Bridge dates to the 1930s; however surviving records show that there has been a bridge at the site since medieval times. The bridge crosses its namesake River Eden and was the main route out of the city when travelling northwards. A surviving map dated to 1685 shows that the city originally had two separate Eden Bridges that were separated by a piece of land known as the sands. During the eighteenth and early nineteenth centuries the bridge underwent repairs and rebuilding due to age and damage from flooding. The current bridge was designed by Sir Robert Smirke in 1812–15 and utilises five elongated arches. Later in 1902, a pedestrian tunnel was created through the bridge on the south side, close to Bitts Park. In 1932, the bridge was widened to accommodate an increase in traffic, with some of the old stonework being reused. The work was overseen by Percy Dalton, who also oversaw the construction of Eden Bridge Gardens.

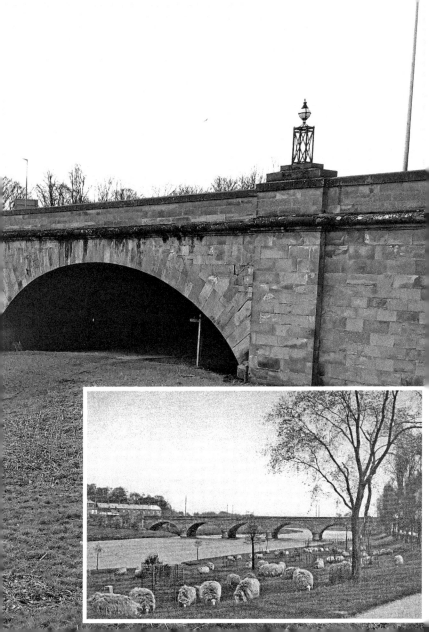

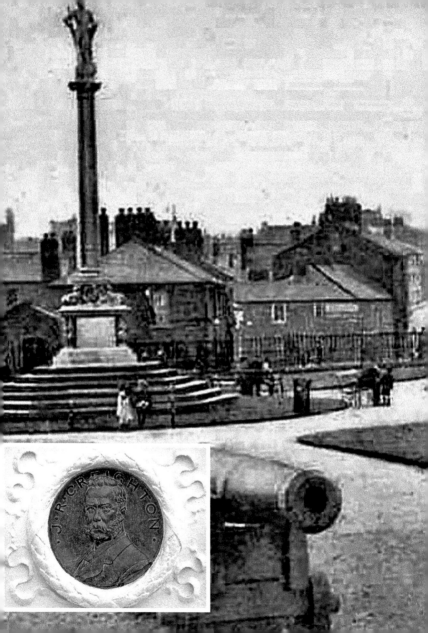

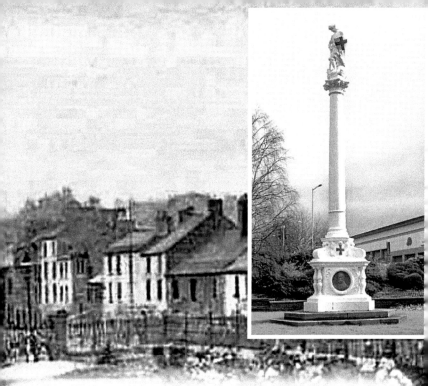

# 18. THE CREIGHTON MEMORIAL, HARDWICKE CIRCUS

At the centre of the Hardwicke Circus is the Creighton Memorial. The monument is dedicated to James Robert Creighton, twice-elected mayor of Carlisle who died in 1898. During his twenty-two years working as a council member he oversaw many important developments in the town including the Tullie House, the old Market Hall and new road layouts. During the 1970s when the Hardwicke Circus roundabout was constructed, the memorial was temporarily removed and later rebuilt close to the original location.

# 19. THE QUEEN VICTORIA MONUMENT

The commemorative statue of Queen Victoria was erected in 1902. It was designed by Sir Thomas Brock to stand at the eastern edge of Bitts Park, surrounded by newly laid out ground in an area renamed Victoria Park. His bronze statue stands high on its pedestal, with Queen Victoria depicted in the popular pose holding an orb and sceptre. The sides of the base contain four reliefs that depict commerce, education, empire, and science and art.

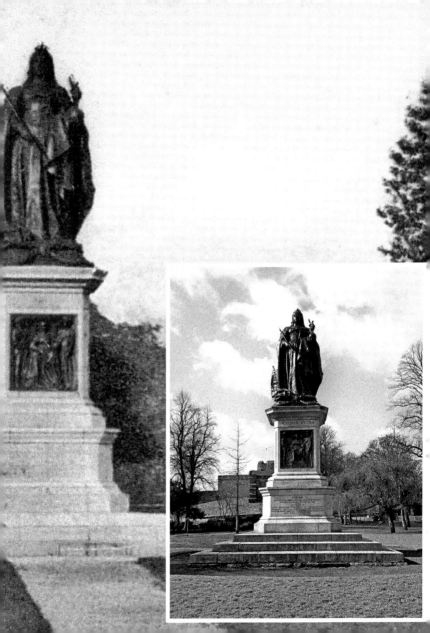

# 20. BITTS PARK

Bitts Park was the first public park to be created in the town close to the edges of the River Eden and Carlisle Castle. The name of the park derives from the word 'bitts', which were small pieces of land used to graze cattle. The park became a popular area for relaxation and recreation with the area close to the riverbank known as the Mayor's Walk. At the beginning of the twentieth century it became the home of the Victoria Monument. The part of the park that houses the statue was first laid out during the 1890s and is located on the site of a former rubbish tip.

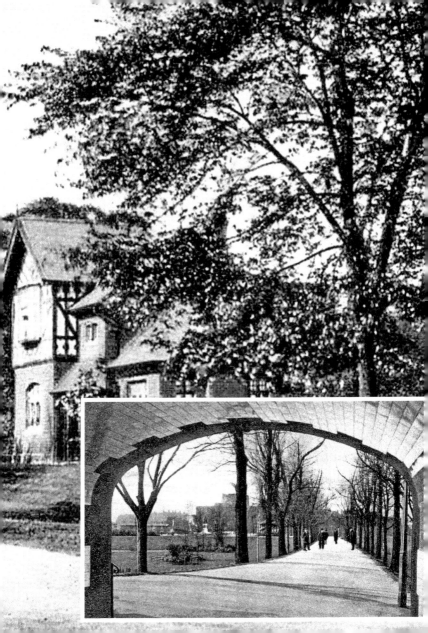

# 21. SCOTCH STREET

Scotch Street, as its name suggests, was the main route into the town from the north and was home to the Scotch Gate. Over the centuries the road played a vital role in controlling trade and people entering and leaving the city from the north. It travels into the centre of the city close to the market cross, where it meets English Street, and continues southwards towards the site of the original English Gate. Until the mid-twentieth century the road was accessible by vehicles; however a large part of the route has been converted for pedestrians.

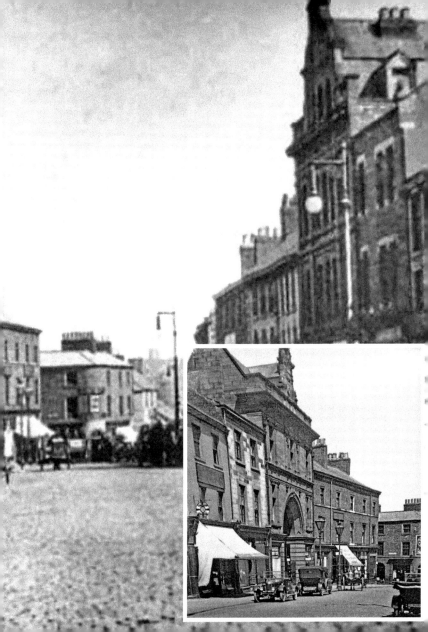

# 22. THE SCOTCH GATE AND PRISON

The Scotch Gate, sometimes referred to as the Rickergate, was located on the eastern side of the city, close to where Scotch Street and Rickergate now meet. The gate was built around 1100 and also housed a prison in secure rooms above the archway. The earliest mention of the gate dates from 1539 and mentions the other gates around Carlisle. A survey undertaken in 1563 stated that the gate was constructed out of wood and in a poor state of repair. From the surviving record we know that after this period the gate was being rebuilt in stone. The gate survived until 1815 when it was demolished to allow the city to expand.

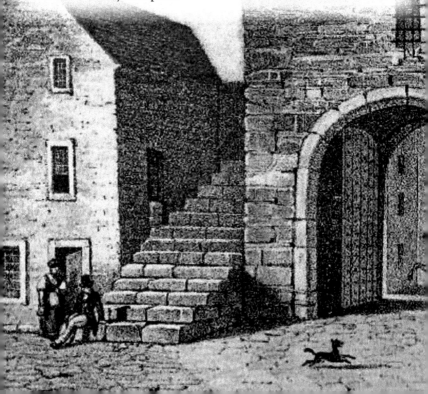

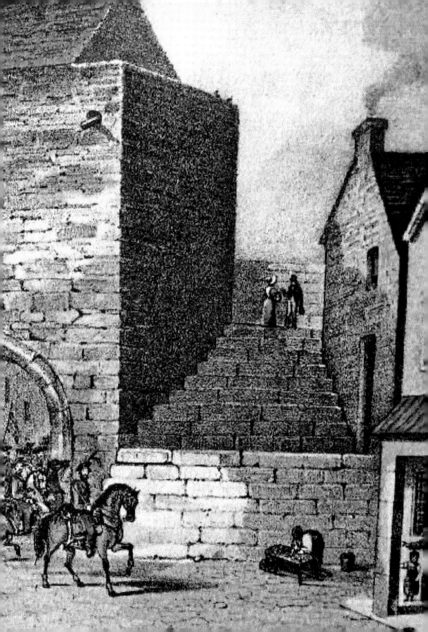

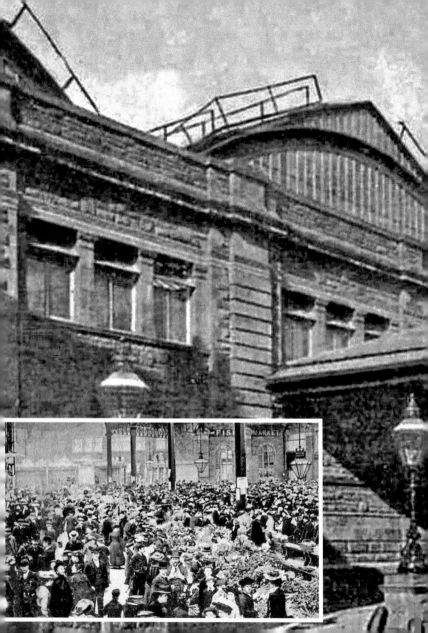

# 23. THE COVERED MARKET

During the Victorian period many large towns and cities constructed large covered markets where goods could be bought and sold without having to worry about poor weather. Carlisle's market was designed for the Carlisle Corporation by Arthur Cawston and Joseph Graham, and the ironwork was provided by Cowans, Sheldon & Co. The market was constructed between 1887 and 1889 and to this day is one of only a handful of original covered markets to survive. Over the years a change in shopping habits has forced the market to adapt, with fewer stalls now being offered. The building has also been used for other purposes including as an events venue, which has welcomed many notable acts including Status Quo, Thin Lizzy and Iron Maiden. During the 1990s one of the entrances from Scotch Street was closed and later the interior was reorganised to accommodate larger retail units.

# 24. THE CHAPEL OF ST ALBAN'S

Tucked away behind the Old Town Hall is the site of the Chapel of St Alban's. The chapel was constructed during the fourteenth century. Unfortunately, the chapel was never consecrated and in 1356 Bishop Weldon made a statute forbidding anyone from worshiping there. Over the centuries St Alban's Row underwent few changes, becoming a home to many small businesses including a popular oyster shop.

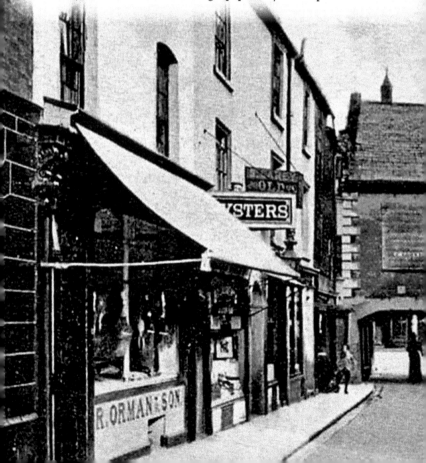

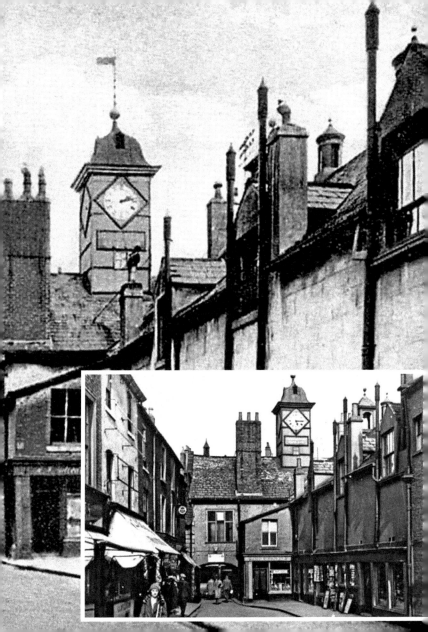

# 25. THE MARKETPLACE

At the heart of the city centre is the marketplace, where for centuries local residents and businesses traded and sold their goods. The origins of the market can be traced back to the Middle Ages. The square has been home to many notable buildings including the Old Town Hall and Guildhall, as well as the Market Cross and Steel Monument. Until the twentieth century the area was accessible by vehicles, with tramlines first being built at the beginning of the twentieth century. The indoor shopping centre known as The Lanes was opened during the 1980s. Nowadays, the area is only accessible to pedestrians and provides a tranquil space to relax.

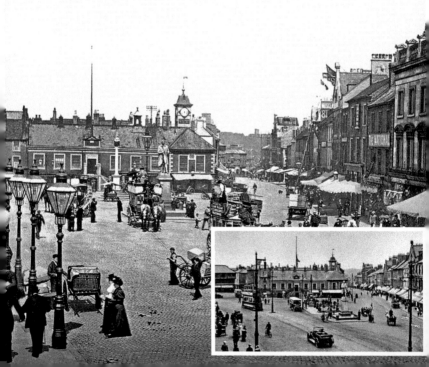

# 26. THE MARKET CROSS

In the middle of the marketplace you will find the Market Cross, a common symbol in most towns and cities during the Middle Ages. In 1352, Edward III granted the city rights to hold an annual fair in August and a year later the first one was held. The current cross stands on the site of the original cross and dates from 1682. It has an unusual design with four sundials and is topped with a lion wearing a crown and holding a scroll. The cross has been the centre of the marketplace for centuries and has witnessed many events from the weekly markets, festive celebrations and announcements including the declaration of war and ascension of new monarchs. The cross is also used as a final marker for people undertaking the Cumbria Way footpath.

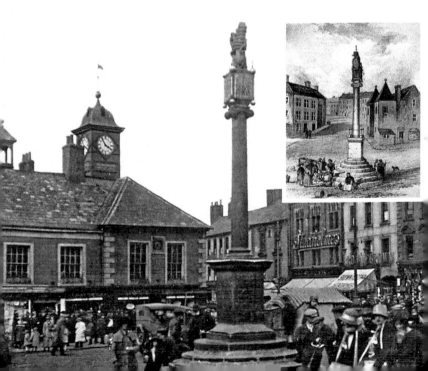

# 27. THE OLD TOWN HALL

In the centre of the marketplace is the Old Town Hall, which dates back to 1668/69 and was built on the foundations of the original medieval town hall. Later in 1717, the building underwent significant alterations including an extension and the construction of the clock tower cupola. The building was further extended during the nineteenth century. In 1886, the bell and bellcote were replaced after a fire damaged the originals. In the small street behind the building is site of the Chapel of St Alban's, which is notable for its small size and unusual design.

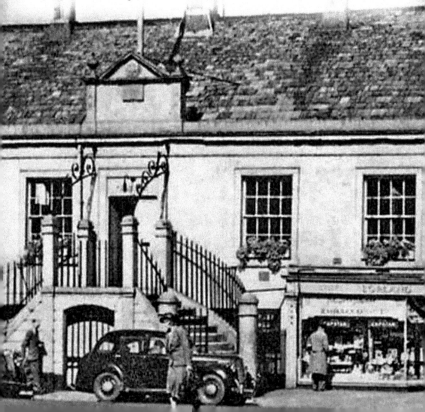

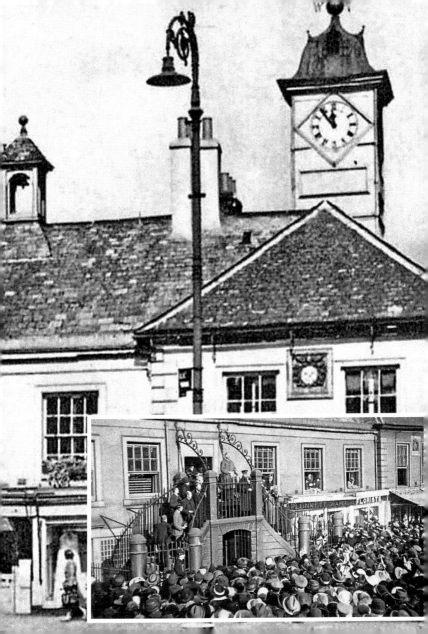

# 28. GLOVER'S ROW

One of the least-known sites in the city is Glover's Row, which originally stood in the centre close to the Market Cross. The street was home to several notable businesses including Blakey's, who operated a shoe shop and manufacturing business, and John Watt & Son, who first opened a coffee business on the street in 1865. During the 1890s, as the town was expanding, space was needed to widen new roads and clear open spaces to make life for the residents and visitors more bearable. It was decided that the street was to be demolished and many of the businesses moved to other parts of the town.

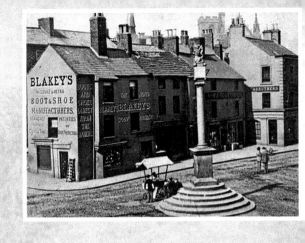

# 29. THE CROWN AND MITRE HOTEL

The site of the Crown and Mitre Hotel has a long history dating back centuries. Famously during the 1745 Jacobite Rebellion, the landlord accommodated rebels who had entered the city. Later during the eighteenth century, it became the main coaching inn on the London, Glasgow and Edinburgh routes. The Crown and Mitre Inn was home to a large assembly hall and was the centre of many local activities; it also attracted many visitors including Sir Walter Scott, who stayed at inn the night before he married Margaret Carpenter at Carlisle Cathedral. In 1902 the old inn was demolished to make way for a new grand hotel that took three years to construct. The new hotel opened in 1905 and over the years has hosted many important guests including President Woodrow Wilson.

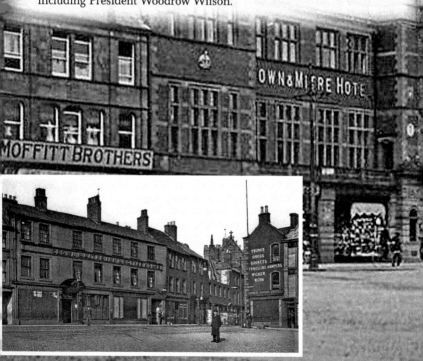

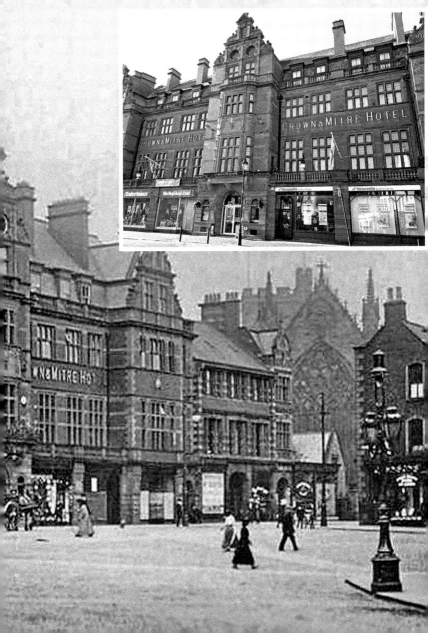

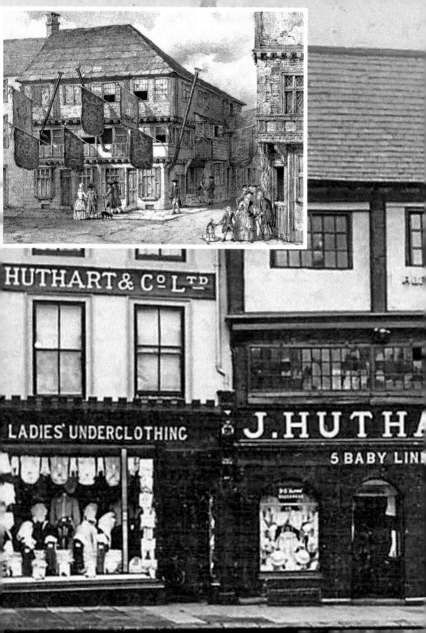

HUTHART & C° L™

LADIES' UNDERCLOTHING

J.HUTHA

5 BABY LIN

# 30. THE GUILDHALL

The Guildhall has been a vital building in the town for centuries. Between 1377 and 1399 the building was owned by a merchant named Richard de Redness, leading to the building sometimes being referred to as the Redness Hall. It has also served as a meeting place for the eight trade guilds that operated in the town. These were the guilds of butchers, merchants, shoemakers, skinners, smiths, tailors, tanners and weavers. The building was also used by the assize courts and quarter sessions until 1807, by which time the building had fallen into a poor state and could no longer be used safely. Over the next two centuries it was home to many local business and underwent a major renovation between 1978 and 1979, which ensured that the original timberwork and wattle-and-daub internal walls were preserved. The building is the only surviving medieval house in the city today.

# 31. ENGLISH STREET

One of the main routes through the city is English Street, which begins behind the Citadel Buildings and travels northwards towards the marketplace, where it meets Scotch Street. Trams were first introduced to the city in 1900, with routes travelling down many of the main streets including English Street. The tram network closed in 1931. English Street is home to many important buildings including Highmore House and has for centuries been one of the main shopping streets in Carlisle. The city centre was pedestrianised in 1989.

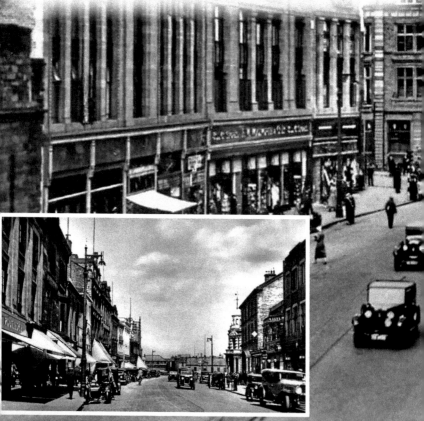

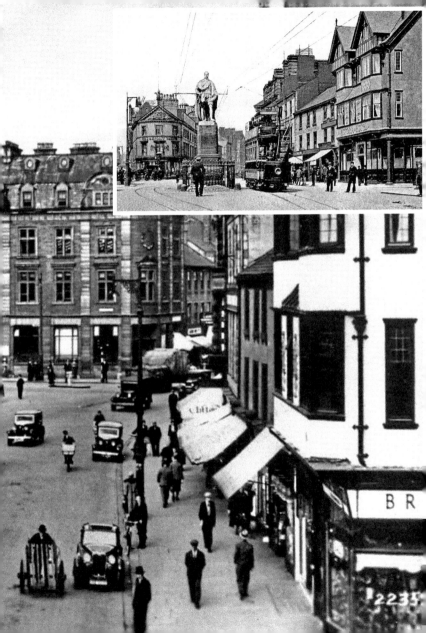

# 32. HIGHMORE HOUSE

The current building marks the site of the original Highmore House, most famous for the role it played during the 1745 Jacobite Rebellion. During this period the house was owned by local accountant Charles Highmore. Previously the house had been owned by the Earls of Egremont and was known as the Earl's Inn. During the rebellion the house hosted Bonnie Prince Charlie, also known as Charles Edward Stuart, during his stay in November 1745 and later accommodated the Duke of Cumberland in December of the same year, when he recaptured the city. The building remained a family home until 1848 when William Potts died. The house was purchased in 1895 by William Wright, who converted it into a large shop. It was demolished in 1930s to make way for a new department store.

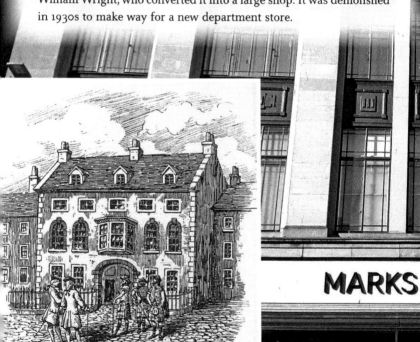

MARKS

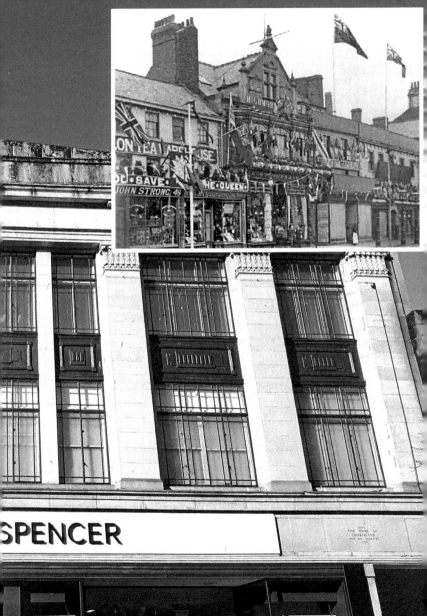

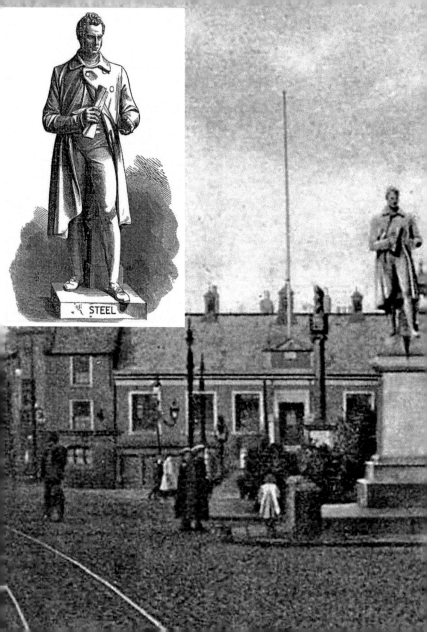
STEEL

# 33. THE STEEL MONUMENT

Close to the site of Highmore House is the grand statue of James Steel. James Steel was born in 1797 and in his later life became involved with the local newspapers, working firstly at the *Carlisle Chronicle* and later for the *Whitehaven Gazette*. During the 1820s he acted as the editor for the *Kendal Chronicle* and in 1829 was appointed editor of the *Carlisle Journal* – by the 1830s the newspaper had become the bestselling paper in Cumberland. He also served as a councillor between 1836 and 1851, and in 1844 was elected as the mayor of Carlisle. James Steel died in 1851 and the current statue was unveiled several years later in 1859, with its original location in the marketplace. In 1989 the statue was cleaned and restored, and it was decided to move the statue to its current location.

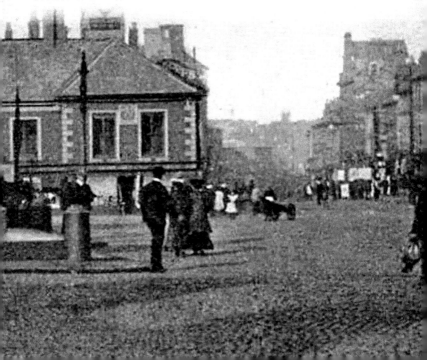

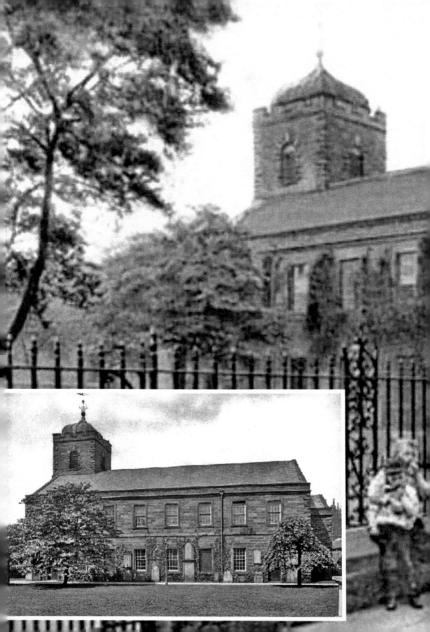

# 34. ST CUTHBERT'S CHURCH

One of Carlisle's lesser-known churches is St Cuthbert's, located close to Carlisle Cathedral and tucked behind the buildings along English Street. The history of a church on this site can be traced back to the seventh century, with one rebuilt in AD 870. It is possible that a church existed at this location before St Cuthbert's visit to Carlisle in AD 685. During the eleventh century the church was rebuilt and the current structure was erected in 1778, although some of the original features dated to the fourteenth century still survive, including a stained-glass window. Another interesting feature is the eighteenth-century pulpit, which is constructed on rails, allowing it to be moved easily. In 1797, Sir Walter Scott married at the nearby St Mary's Church, the record of which was moved to St Cuthbert's when St Mary's was demolished. The churchyard is also the location of many eighteenth-century gravestones that mark the graves of Jacobite soldiers who died during Bonnie Prince Charlie's 1745 rebellion. Unusually, the church is not oriented along an east to west axis, with its layout instead dictated by its location beside the old Roman road that travelled northwards out of the city.

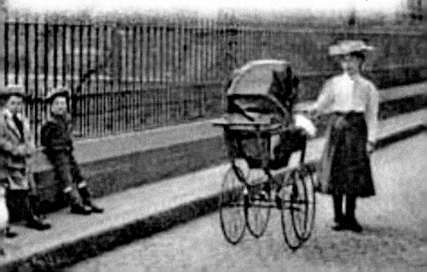

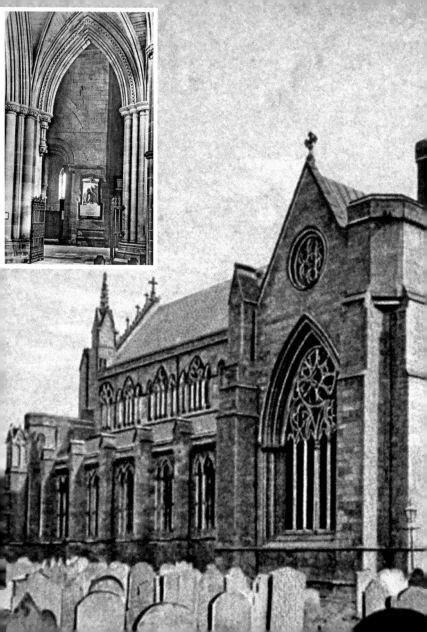

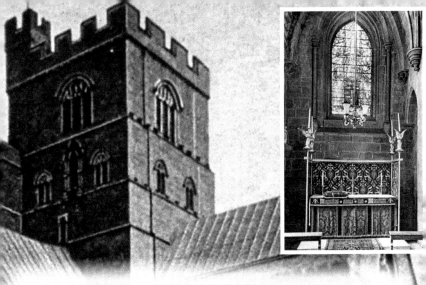

# 35. CARLISLE CATHEDRAL

The imposing Carlisle Cathedral, also known as the Cathedral Church of the Holy and Undivided Trinity, was founded as an Augustinian priory in 1122 by Henry I and became a cathedral in 1133. The first prior was Athelwold, who later became the first Bishop of Carlisle from 1133–55. During the thirteenth and fourteenth centuries a Franciscan and Dominican friary were founded close to the cathedral and during the Dissolution of the Monasteries in the sixteenth century these institutions were dissolved. During the English Civil War part of the cathedral's nave was demolished by the Scottish Presbyterian Army to provide stone to reinforce the castle. Between 1853 and 1870 the cathedral was restored by Ewan Christian. Today the building is notable for its fifteenth-century misericords, ornate east window and the gilt canopy over the high altar, designed by Sir Charles Nicholson. It is also the second smallest cathedral of England's ancient cathedrals, due to the loss of various parts of the original structure over the centuries.

# 36. THE EAST WINDOW, CARLISLE CATHEDRAL

The east window dates to around 1350 and was constructed as part of the rebuilding works undertaken over the decades following the church fire of 1292. It is around 50 feet in height and has been suggested to be the work of Ivo de Raughton; however there is not enough evidence to confirm this. Only parts of the original stained glass survive, and these can be seen in the upper part of the window, which depicts the Last Judgement of Jesus Christ. The lower part of the window was created in 1861 by Harman & Co. and depicts the life of Jesus. It is dedicated to Bishop Hugh Percy.

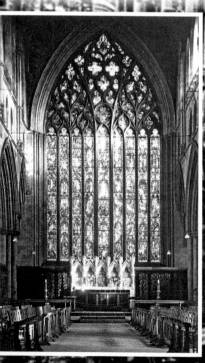

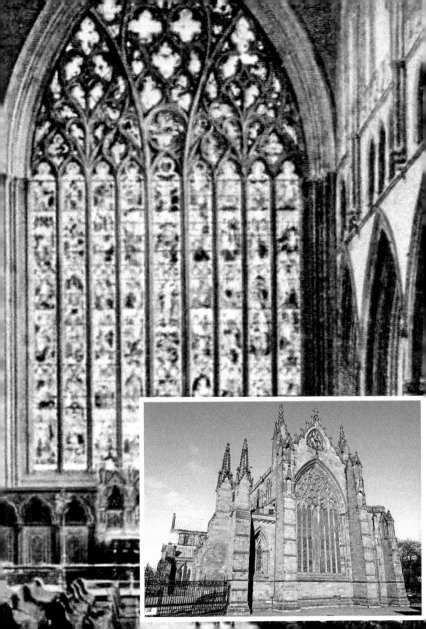

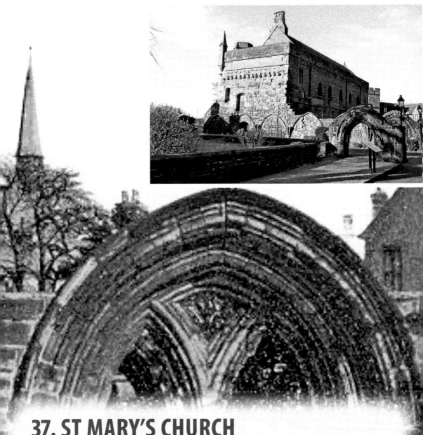

# 37. ST MARY'S CHURCH

During the Middle Ages the town consisted of two parishes: St Mary's and St Cuthbert's. St Mary's was originally constructed as a nave for Carlisle Cathedral and in 1797 Sir Walter Scott and Charlotte Carpenter married there. In 1870 it was decided that it should instead have its own building and a new church was constructed. In 1932 the parish joined with the neighbouring St Paul's, forming a larger area and the church closed in 1938. The church was demolished in 1954 and the site is now marked by a garden, close to the east window.

# 38. THE ARCHWAY

When heading north from the cathedral the route passes under an impressive archway that leads to Abbey Street. The archway was originally constructed in 1527 by Prior Slee and allows access to the nearby streets including Abbey Street, Paternoster Row, Castle Street and Fisher Street, where the clergy had allotments.

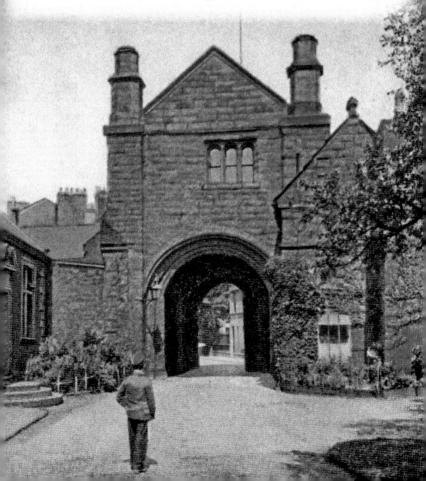

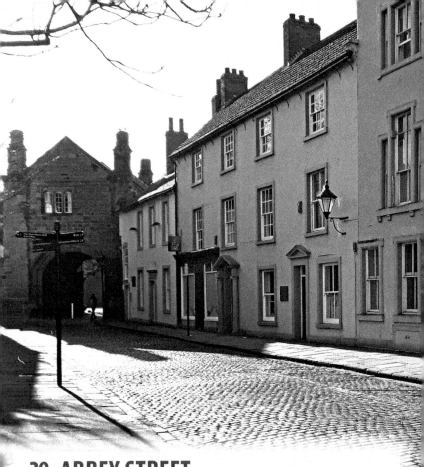

# 39. ABBEY STREET

Abbey Street is tucked away close to Carlisle Cathedral and is notable as the home of Tullie House. The origins of the street can be traced back to the early Middle Ages and it has had a long association with the neighbouring cathedral. Over the centuries the church has owned various properties and land as well as providing accommodation for members of the clergy.

# 40. TULLIE HOUSE

This Jacobean building was constructed in 1689 for the Tullie family, who resided in the house until the 1840s. Later it became a cloth warehouse and afterwards was to be demolished; however local residents were able to save the building by raising funds by public subscription. It reopened on 8 November 1893 as a museum and art gallery, with a new art and technical college located behind the original building. During the 1950s the school moved out of the building and later in 1986 the library also moved. Today the museum houses a large archaeological collection of Roman artefacts from the town, extensive botanical and zoological specimens as well as paintings by many notable artists.

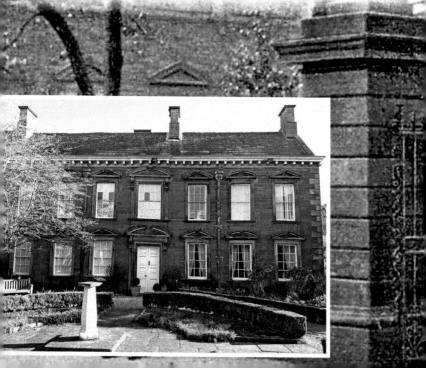

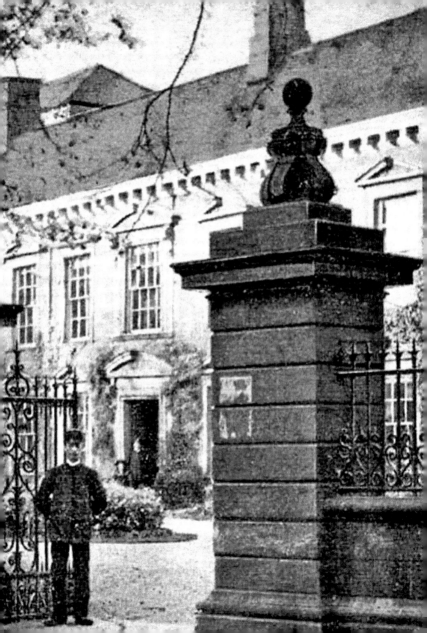

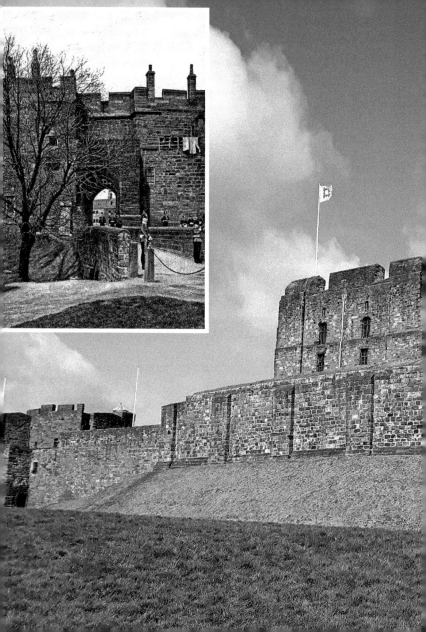

# 41. CARLISLE CASTLE

The castle was first constructed by William II in 1092, when the area was still considered to be part of Scotland. He ordered that a motte-and-bailey castle be constructed at the site to the north of the town close to the River Eden, where the Roman fort once stood. Later in 1122, Henry I ordered a stone castle to be constructed at the site, with the stone keep and defensive walls being constructed. Between the thirteenth and seventeenth centuries the castle was the headquarters for the Western March, which was a buffer zone between the Anglo-Scottish border. During the English Civil War, it was besieged by Parliamentary forces and later during the Jacobite Rebellion of 1745 the castle and city were seized by the Jacobites. After the rebellion the castle fell into a state of neglect and it wasn't until the nineteenth century that the castle underwent significant renovations, eventually providing a base for the Border Regiment until the mid-twentieth century. One of the castle's most famous prisoners was Mary, Queen of Scots, who was imprisoned in the Warden's Tower for a few months in 1567.

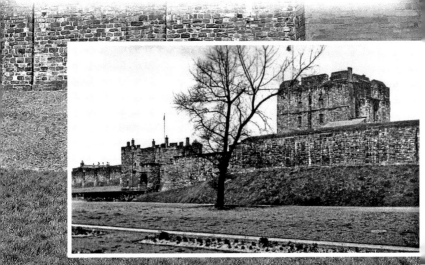

# 42. THE IRISH GATE

The Irish Gate, sometimes known as the Caldew Gate due to its proximity to the River Caldew, is one of several important gateways in Carlisle. In July 1315, the Scots besieged the city after the Battle of Bannockburn. Records from the time state that the gate came under direct attack when the Scots built a siege engine that repeatedly threw large stones towards the gate, evidence of which was found in Annetwell Street in 1878 during building work. A surviving record from 1385 reported that the gates could not be closed properly and that it may have taken until 1428 for funds to be made available to remedy the issue and repair the adjacent city walls. By 1563, the gate was once again recorded as being in a poor condition. Colonel Thomas Fitch, who was the governor of Carlisle, ordered that the doors from the recently demolished Wolsty Castle near Allonby, were to be brought to the city and hung on the Irish Gate. Over the next few centuries little is known of the gate; however when Nathaniel Buck visited in 1738 and made drawings of the walls and gates around the city, the Irish Gate depicted as being in a good condition. By 1811 it was decided the demolish the gate to make space for the expanding city. During the 1960s and 1970s it was suggested that the gate could be reconstructed, with the option to construct a footbridge also proposed. It took until 2000, when the new footbridge was opened to celebrate the millennium. The location of the original gate is also marked by a new red-brick archway.

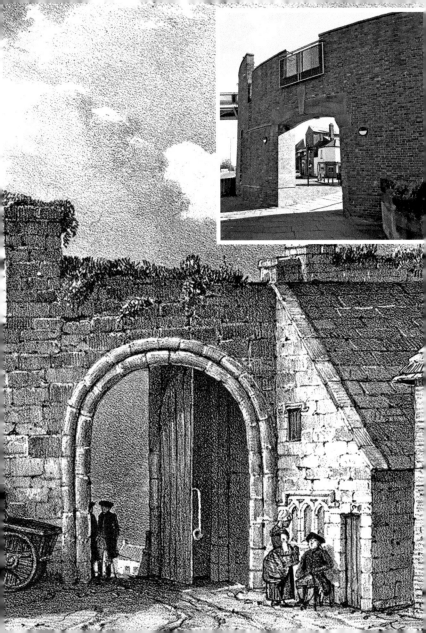

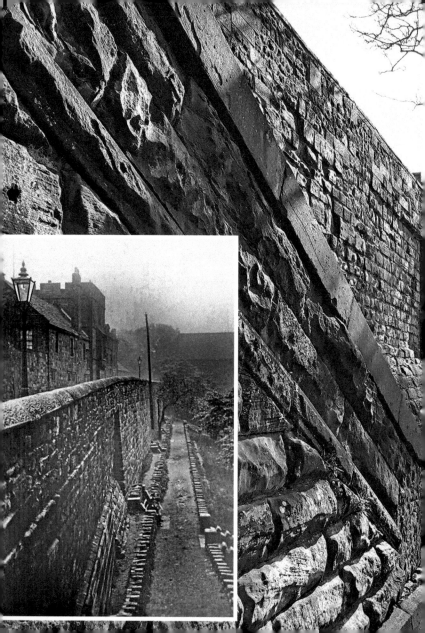

# 43. THE WEST WALLS

Carlisle's location close to the Scottish border has meant that over the centuries the city has been attacked on many occasions. Romans were the first people to construct defences around the town. In the twelfth century the wooden walls were replaced by stone fortifications. Over the later century the walls fell out of use and into a poor state of repair. By the eighteenth century there was an urgent need to find space to allow the town to expand and in 1807 Parliament passed an Act allowing the demolition of the walls to take place. The North and East Walls were eventually demolished around 1810 and some of the stone was reused in various projects including the new Citadel Buildings and the Eden Bridge. The West Walls were retained as they supported the land close to the River Caldew. Over the centuries this part of the wall has undergone many changes and until 1952 houses could be found built against the walls. Today the area is quiet and tranquil.

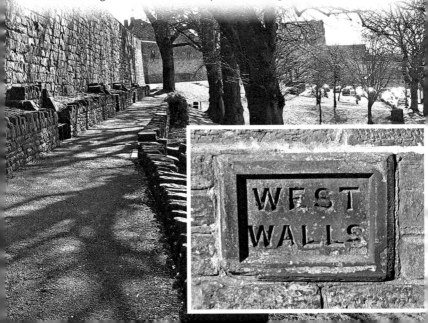

# 44. DIXON'S CHIMNEY AND SHADDON MILL

One of the most prominent landmarks in Carlisle is the large chimney at Shaddon Mill. The mill was constructed in 1836 as a cotton mill and the chimney was constructed to be 305 feet tall so that the large amount of smoke generated didn't affect the city. The internal diameter of the chimney is 17 feet 6 inches and 10-foot walls are at the base. Upon completion of the factory the buildings and chimney were the largest in Britain and the chimney earned the accolade of being the eighth largest in the world. In 1883 Peter Dixon & Sons Ltd went into liquidation and the mill was taken over by Robert Todd & Sons Ltd, who converted the mill to produce wool. Later in 1950, the height of the chimney was reduced to 290 feet.

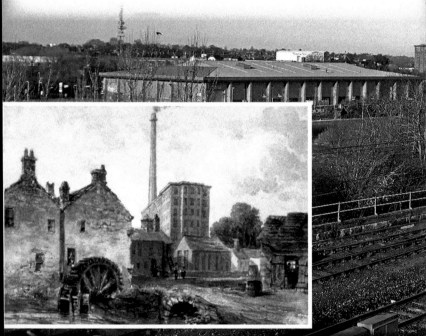

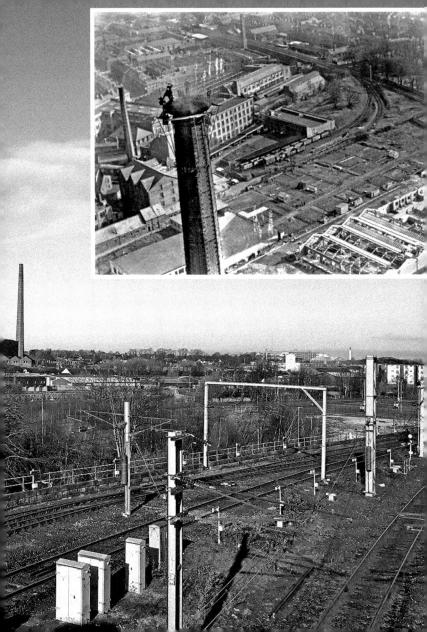

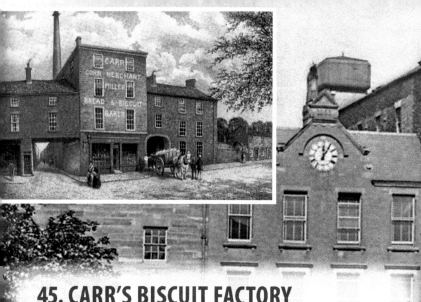

## 45. CARR'S BISCUIT FACTORY

In 1831, Jonathan Dodgson Carr created a small bakery and factory in the town which proved so popular that he received a royal warrant in 1841. By the mid-1840s Carr's was the largest bakery business in the whole of Britain, producing a dry biscuit that would stay fresh on long journeys. His approach to the business was somewhat unusual for the time, as he not only baked his products but also milled the flour himself. The factory ran almost non-stop with biscuits being produced during the daytime and bread at night. He died in 1884, but by then his company made over 120 varieties of biscuit and employed around 1,000 workers. In 1894 the company was renamed Carr and Co. Ltd but became a private company again in 1908. The business remained family-run until 1931 when his sons sold the business to Cavenham Foods and later became part of McVitie's in 1971. In more recent times the factory has suffered from severe flooding in 2005 and 2016. It was also in 2012 that they lost their royal warrant due to changing tastes in the royal household.

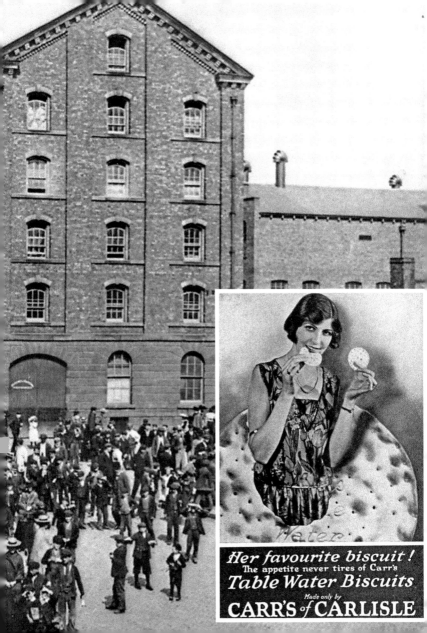

*Her favourite biscuit!*
The appetite never tires of Carr's
*Table Water Biscuits*
Made only by
**CARR'S** of **CARLISLE**

# 46. CALDEWGATE

The area of Carlisle known as Caldewgate was created on 19 August 1834 as a parish for the newly built Holy Trinity Church. It was built to house local workers for the town's industries. The parish is located to the west of the city and is home to several important manufacturing sites including Shaddon Mill and its imposing Dixon's Chimney and Carr's Biscuit Factory.

# 47. HOLY TRINITY CHURCH

The former Holy Trinity Church was built as part of the new parish of Caldewgate. The church was designed by architect Thomas Rickman and was constructed between 1828 and 1830 at a cost of around £6,500. The new church was constructed in the popular Gothic style and incorporated a chancel, nave and spire, which was 132 feet in height. Over the decades the church underwent many alterations. In 1845, a stained-glass window for the chancel was given by a Mrs Thwaites and later, in 1888, the side gallery was removed. At the same time the seating was changed to new open benches and the organ was restored. During the twentieth century the building fell into a poor state and became unsafe. To help with the ongoing issues the spire was removed in 1947, but it was decided in 1982 that demolition was the best option. A new church named after the original was built nearby in the 1980s and the original site is now a park.

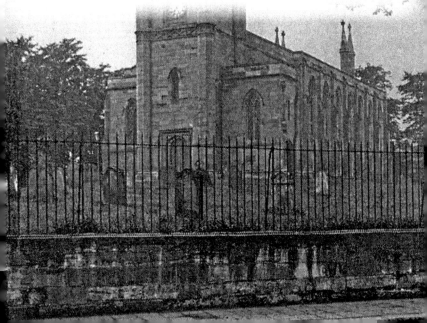

# 48. THE OLD CUMBERLAND INFIRMARY

Over the past two centuries Carlisle has been home to several hospitals and infirmaries. One of the earliest was built in 1820 to treat infectious diseases. It was located in Collier Lane, which is now the location of Carlisle train station. The Cumberland Infirmary was built between 1830 and 1832 and was designed by Richard Tattersall in the popular classical style. The hospital provided healthcare services to the residents of the town who had helped towards the construction costs, raised by subscription. Over the decades the hospital continued to provide care and gradually this extended, through contributions, to allow poorer people to receive treatment. The Fusehill Workhouse also provided a healthcare provision to inmates and in 1883 the Border Home for the Incurables was opened to provide support to people with chronic disabilities and illnesses. In 1904 a new Isolation Hospital was opened on Moorhouse Road to treat smallpox.

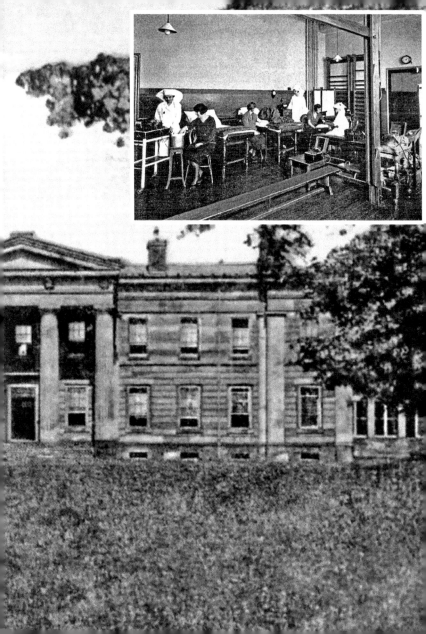

# 49. PORT CARLISLE

A few miles upstream from the city is Port Carlisle, once a bustling hub of commerce and trade for the city. The port is around 1 mile from Bowness-on-Solway and was originally known as Fisher's Cross. The first port was constructed in 1819 and in 1823 a canal link was added, which helped to transport goods to Carlisle basin. The canal was 11 1/4 miles long with eight locks. In 1853 the canal was closed and the port started to silt up. A year later the Port Carlisle Dock & Railway constructed a railway line that was only open for two years, closing in 1856. The same year the Carlisle and Silloth Bay Railway & Dock Co. was built as an extension of the Port Carlisle line, as the silting of the Solway made Port Carlisle unusable. The line closed for the final time in 1932.

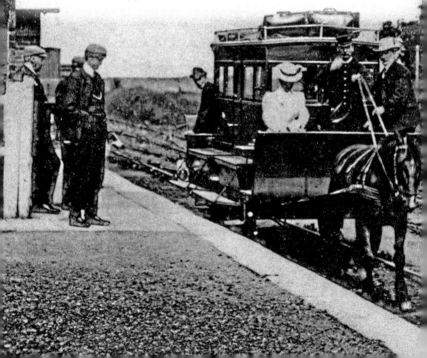